D1065115

A *Little* Book of
CHRISTMAS
Stories
and
Recipes

Edited by
Lena Tabori

A Welcome Book

Andrews McMeel
Publishing

Kansas City

CONTENTS

STORIES

RECIPES

The Three
Wise Men

ST. MATTHEW 2:1–14

Now when Jesus was born in Bethlehem of Judæa in the days of Herod the king, behold, there came wise men from the east to Jerusalem.

Saying, Where is he that is born King of the Jews? for we have seen his star in the east, and are come to worship him.

When Herod the king had heard these things, he was troubled, and all Jerusalem with him.

And when he had gathered all the chief priests and scribes of the people together, he demanded of them where Christ should be born.

And they said unto him, In Bethlehem of Judæa: for thus it is written by the prophet,

And thou Bethlehem, in the land of Juda, art not the least among the princes of Juda: for out of thee shall come a Governor, that shall rule my people Israel.

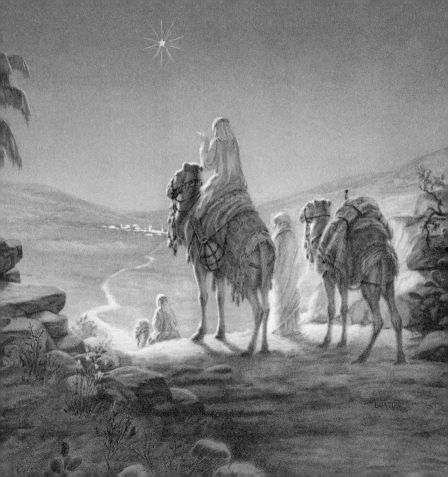

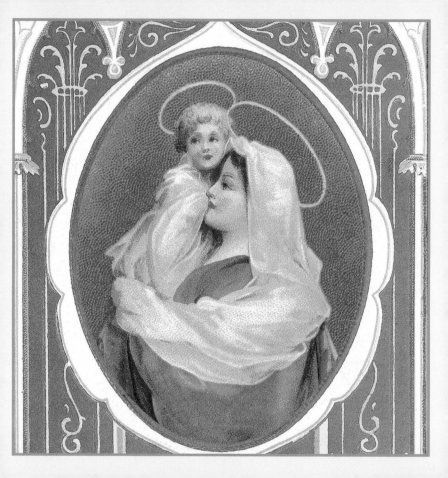

Then Herod, when he had privily called the wise men, enquired of them diligently what time the star appeared.

And he sent them to Bethlehem, and said, Go and search diligently for the young child; and when ye have found him, bring me word again, that I may come and worship him also.

When they had heard the king, they departed; and, lo, the star, which they saw in the east, went before them, till it came and stood over where the young child was.

When they saw the star, they rejoiced with exceeding great joy.

And when they were come into the house, they saw the young child with Mary his mother, and fell down, and worshipped him: and when they had opened their treasures, they presented unto him gifts; gold, and frankincense, and myrrh.

And being warned of God in a dream that they should not return to Herod, they departed into their own country another way.

And when they were departed, behold, the angel of the Lord appeareth to Joseph in a dream, saying, Arise, and take the young child and his mother, and flee into Egypt, and be thou there until I bring thee word: for Herod will seek the young child to destroy him.

When he arose, he took the young child and his mother by night, and departed into Egypt.

Chocolate Walnut Pie

Crust:

1 CUP ALL-PURPOSE WHITE FLOUR

$1/2$ TEASPOON SALT

6 TABLESPOONS BUTTER

$1/4$ CUP ICE WATER

Filling:

4 EGGS PLUS 2 YOLKS

PINCH OF SALT

1 TEASPOON VANILLA EXTRACT

$1/2$ CUP BROWN SUGAR

$1/2$ CUP SUGAR

1 CUP DARK CORN SYRUP

$1/2$ CUP LIGHT CORN SYRUP

2 TABLESPOONS MELTED BUTTER

1 $1/2$ CUPS CHOPPED WALNUTS

4 OZ. SEMISWEET CHOCOLATE PIECES

1 PINT HEAVY CREAM

1 TABLESPOON SUGAR

1. Combine flour and salt. Cut in the butter and add ice water. Blend quickly.

2. Divide into equally sized pieces and shape into balls.

3. Flatten, cover with plastic wrap, and refrigerate for $1/2$ hour.

4. Preheat the oven to 375°F.

5. On a floured board, roll one piece of dough out into a circle and line a pie pan with it (let the ends hang over).

6. To make the filling, combine eggs, yolks, salt, and vanilla and mix well. Add both sugars and whip until sugar is nearly dissolved. Mix in syrups, melted butter, and nuts.

7. Sprinkle the chocolate pieces into the pie shell and add the filling.

8. Bake for 15 minutes, lower temperature to 300°F, and bake another 40 minutes, until the pie is set.

9. Cool before slicing.

10. Mix heavy cream and sugar; whip until you get soft peaks.

11. Serve pie with whipped cream.

Born in Bethlehem

St. Luke 2:1–16

And it came to pass in those days, that there went out a decree from Caesar Augustus, that all the world should be taxed. (And this taxing was first made when Cyrenius was governor of Syria.)

And all went to be taxed, every one into his own city.

And Joseph also went up from Galilee, out of the city of Nazareth, into Judæa, unto the city of David, which is called Bethlehem; (because he was of the house and lineage of David:)

To be taxed with Mary his espoused wife, being great with child.

And so it was, that, while they were there, the days were accomplished that she should be delivered.

And she brought forth her firstborn son, and wrapped him in swaddling clothes, and laid him in a manger; because there was no room for them in the inn.

And there were in the same country shepherds abiding in the field, keeping watch over their flock by night.

And, lo, the angel of the Lord came upon them, and the glory of the

Lord shone round about them: and they were sore afraid.

And the angel said unto them, Fear not: for, behold, I bring you good tidings of great joy, which shall be to all people.

For unto you is born this day in the city of David a Saviour, which is Christ the Lord.

And this shall be a sign unto you; Ye shall find the babe wrapped in swaddling clothes, lying in a manger.

And suddenly there was with the angel a multitude of the heavenly host praising God, and saying,

Glory to god in the highest, and on earth peace, good will toward men.

And it came to pass, as the angels were gone away from them into

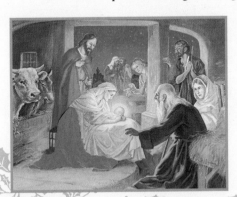

heaven, the shepherds said one to another, Let us now go even unto Bethlehem, and see this thing which is come to pass, which the Lord hath made known unto us.

And they came with haste, and found Mary, and Joseph, and the babe lying in a manger.

Chocolate Christmas Yule Log

This sweet and traditional dessert has a delicious chocolate ricotta filling and a whipped cream frosting. You can transform it into a log by cutting a 1 1/2-inch-thick diagonal slice off each end of the roll, and placing one end piece on the side of the roll and one end piece on top of the roll to resemble a log with cut branches.

Cake

1/2 CUP CAKE FLOUR

1/4 CUP UNSWEETENED COCOA
 POWDER

1 TEASPOON BAKING POWDER

1/4 TEASPOON SALT

1/2 CUP WHITE SUGAR

3 EGGS, SEPARATED

1/4 CUP MILK

1/4 TEASPOON CREAM OF TARTAR

Filling

1 1/4 RICOTTA CHEESE

1/2 CUP REDUCED-FAT CREAM
 CHEESE (NEUFCHATEL)

1/2 CUP CONFECTIONERS' SUGAR

1/2 TEASPOON VANILLA EXTRACT

1/4 CUP SEMISWEET CHOCOLATE
 MINI PIECES

Frosting

1 CUP HEAVY CREAM

4 TABLESPOONS CONFECTIONERS'
 SUGAR

1/2 TEASPOON VANILLA EXTRACT

2 TABLESPOONS ORANGE-FLAVOR
 LIQUEUR

1/2 CUP GRATED SEMISWEET
CHOCOLATE

1. Preheat oven to 375°F. Grease 15 x 10-inch jellyroll pan; line pan with greased waxed paper (or use parchment paper) and dust with flour.

2. Sift together flour, cocoa powder, baking powder, and salt.

3. In a small bowl, use mixer at high speed to beat egg yolks and 1/4 cup granulated sugar until thick and lemon colored, about 5 minutes. At low speed, alternately beat milk and flour mixture into egg mixture.

4. In a large bowl, using clean beaters and with mixer at high speed, beat egg whites and cream of tartar. Beating at high speed, gradually sprinkle in 1/4 cup granulated sugar until sugar dissolves and whites stand in stiff peaks.

5. Fold one-third of beaten whites into batter. Fold in remaining whites. Spread batter in prepared pan; smooth top.

6. Bake until set, 10–12 minutes.

7. Dust a clean tea towel with confectioners' sugar. When cake is done, turn out onto towel. Carefully remove waxed paper. Trim cake edges. Starting from the long side, roll up the cake with the towel in place to cool it down. Place seam-side down on a rack until completely cool, 40–50 minutes.

8. Meanwhile, prepare ricotta filling. Mix together everything except the chocolate pieces. Stir in the chocolate pieces last. Cover and refrigerate while the cake is cooling.

9. Assemble the cake: Gently unroll and remove tea towel. Spread the filling over the cake

almost to the edges. Starting from the same long side as before, roll the cake back to seam-side down position and put on a platter.

10. To prepare the frosting, beat heavy cream and confectioners' sugar at medium speed until soft peaks form. Using a rubber spatula, fold in the vanilla. With a metal spatula, spread the whipped cream frosting over the cake. Refrigerate at least 2 hours before serving. Sprinkle top of cake with grated chocolate just before serving.

Serves 12

The Birds' Christmas Carol

KATE DOUGLAS WIGGIN

I. A Little Snow Bird

It was very early Christmas morning, and in the stillness of the dawn, with the soft snow falling on the housetops, a little child was born in the Bird household.

They had intended to name the baby Lucy, if it were a girl; but they had not expected her on Christmas morning, and a real Christmas baby was not to be lightly named—the whole family agreed in that.

They were consulting about it in the nursery. Mr. Bird said that he had assisted in naming the three boys, and that he should leave this matter entirely to Mrs. Bird; Donald wanted the child called "Dorothy," after a pretty, curly-haired girl who sat next to him in school; Paul chose "Luella," for Luella was the nurse who had been with him during his whole babyhood, up to the time of his first trousers, and the name suggested all sorts of comfortable things. Uncle Jack said that the first girl should always be named for her mother,

no matter how hideous the name happened to be.

Grandma said that she would prefer not to take any part in the discussion, and everybody suddenly remembered that Mrs. Bird had thought of naming the baby Lucy, for Grandma herself; and, while it would be indelicate for her to favor that name, it would be against human nature for her to suggest any other, under the circumstances.

Hugh, the "hitherto baby," if that is a possible term, sat in one corner and said nothing, but felt, in some mysterious way, that his nose was out of joint; for there was a newer baby now, a possibility he had never taken into consideration; and the "first girl," too,—a still higher development of treason, which made him actually green with jealousy.

But it was too profound a subject to be settled then and there, on the spot; besides, Mamma had not been asked, and everybody felt it rather absurd, after all, to forestall a decree that was certain to be absolutely wise, just, and perfect.

The reason that the subject had been brought up at all so early in the day lay in the fact that Mrs. Bird never allowed her babies to go overnight unnamed. She was a person of so great decision of character that she would have blushed at such a thing; she said that to let blessed babies go dangling and dawdling about without names, for months and months, was enough to ruin them for life. She also said that if one

could not make up one's mind in twenty-four hours it was a sign that—But I will not repeat the rest, as it might prejudice you against the most charming woman in the world.

So Donald took his new velocipede and went out to ride up and down the stone pavement and notch the shins of innocent people as they passed by, while Paul spun his musical top on the front steps.

But Hugh refused to leave the scene of action. He seated himself on the top stair in the hall, banged his head against the railing a few times, just by way of uncorking the vials of his wrath, and then subsided into gloomy silence, waiting to declare war if more "first girl babies" were thrust upon a family already surfeited with that unnecessary article.

Meanwhile dear Mrs. Bird lay in her room, weak, but safe and happy, with her sweet girl baby by her side and the heaven of motherhood opening again before her. Nurse was making gruel in the kitchen, and the room was dim and quiet. There was a cheerful open fire in the grate, but though the shutters were closed, the side windows that looked out on the Church of Our Saviour, next door, were a little open.

Suddenly a sound of music poured out into the bright air and drifted into the chamber. It was the boy choir singing Christmas anthems. Higher and higher rose the clear, fresh voices, full of hope and cheer, as children's voices always are. Fuller and fuller grew the burst of melody as one glad strain fell upon another in joyful harmony:—

21

"Carol, brothers, carol,
 Carol joyfully,
 Carol the good tidings,
 Carol merrily!
And pray a gladsome Christmas
 For all your fellow-men:
Carol, brothers, carol,
 Christmas Day again."

One verse followed another, always with the same sweet refrain:—

"And pray a gladsome
 Christmas
 For all your fellow-men:
Carol, brothers, carol,
 Christmas Day again."

Mrs. Bird thought, as the music floated in upon her gentle sleep, that she had slipped into heaven with her new baby, and that the angels were bidding them welcome. But the tiny bundle by her side stirred a little, and though it was scarcely more than the ruffling of a feather, she awoke; for the mother-ear is so close to the heart that it can hear the faintest whisper of a child.

She opened her eyes and drew the baby closer. It looked like a rose dipped in milk, she thought, this pink and white blossom of girlhood, or like a pink cherub, with its halo of pale yellow hair, finer than floss silk.

"Carol, brothers, carol,
 Carol joyfully,
Carol the good tidings,
 Carol merrily!"

The voices were brimming over with joy.

"Why, my baby," whispered Mrs. Bird in soft surprise, "I had forgotten what day it was. You are a little Christmas child, and we will name you 'Carol'—mother's Christmas Carol!"

"What!" said Mr. Bird, coming in softly and closing the door behind him.

"Why, Donald, don't you think 'Carol' is a sweet name for a Christmas baby? It came to me

23

just a moment ago in the singing, as I was lying here half asleep and half awake."

"I think it is a charming name,

dear heart, and sounds just like you, and I hope that, being a girl, this baby has some chance of being as lovely as her mother;"— at which speech from the baby's papa Mrs. Bird, though she was as weak and tired as she could be, blushed with happiness.

And so Carol came by her name.

Of course, it was thought foolish by many people, though Uncle Jack declared laughingly that it was very strange if a whole family of Birds could not be indulged in a single Carol; and Grandma, who adored the child, thought the name much more appropriate than Lucy, but was glad that people would probably think it short for Caroline.

Perhaps because she was born in holiday time, Carol was a very happy baby. Of course, she was too

24

tiny to understand the joy of Christmas-tide, but people say there is everything in a good beginning, and she may have breathed in unconsciously the fragrance of evergreens and holiday dinners; while the peals of sleigh-bells and the laughter of happy children may have fallen upon her baby ears and wakened in them a glad surprise at the merry world she had come to live in.

Her cheeks and lips were as red as holly-berries; her hair was for all the world the color of a Christmas candle-flame; her eyes were bright as stars; her laugh like a chime of Christmas-bells, and her tiny hands forever outstretched in giving.

Such a generous little creature you never saw! A spoonful of bread and milk had always to be taken by Mamma or nurse before Carol could enjoy her supper; whatever bit of cake or sweetmeat found its way into her pretty fingers was straightway broken in half to be shared with Donald, Paul, or Hugh; and when they made believe nibble the morsel with affected enjoyment, she would clap her hands and crow with delight.

"Why does she do it?" asked Donald thoughtfully. "None of us boys ever did."

"I hardly know," said Mamma, catching her darling to her heart, "except that she is a little Christmas child, and so she has a tiny share of the blessedest birthday the world ever knew!"

Red and White Peppermint Cake

1 BOX OF YOUR FAVORITE VANILLA
 CAKE MIX
15 DROPS RED FOOD COLORING
1 BOX CONFECTIONERS' SUGAR
1 STICK BUTTER, SOFTENED
3 TABLESPOONS MILK
1 TEASPOON PEPPERMINT EXTRACT
1 CUP CRUSHED CANDY CANES

Cake

1. Prepare cake batter according to directions. Then pour 3/4 of the batter into a round cake pan. Add food coloring to the remaining batter and mix well.
2. Pour colored batter carefully over white batter. Then, with a knife, slowly cut through the batter so that a swirl effect is created with the red and white batters. Do not overmix.
3. Bake according to package directions.
4. Remove from oven and set aside to cool for at least 15 minutes before removing from pan.

Icing

1. Combine sugar, butter, milk, and peppermint extract in a bowl.
2. Ice cake once it is cooled (approximately 1 hour).
3. Sprinkle icing with crushed candy canes and serve.

A Merry Christmas

from *Little Women*

LOUISA MAY ALCOTT

Jo was the first to wake in the gray dawn of Christmas morning. No stockings hung at the fireplace, and for a moment she felt as much disappointed as she did long ago, when her little sock fell down because it was so crammed with goodies. Then she remembered her mother's promise and, slopping her hand under her pillow, drew out a little crimson-covered book. She knew it very well, for it was that beautiful old story of the best life ever lived, and Jo felt that it was a true guidebook for any pilgrim going the long journey. She woke Meg with a "Merry Christmas," and bade her see what was under her pillow. A green-covered book appeared, with the same picture inside, and a few words written by their mother, which made their one present very precious in their eyes. Presently Beth and Amy woke to rummage and find their little books also—one dove-colored, the other blue—and all sat looking at and talking about them, while the east grew rosy with the coming day.

In spite of her small vanities, Margaret had a sweet and pious

nature, which unconsciously influenced her sisters, especially Jo, who loved her very tenderly, and obeyed her because her advice was so gently given.

"Girls," said Meg seriously, looking from the tumbled head beside her to the two little nightcapped ones in the room beyond, "Mother wants us to read and love and mind these books, and we must begin at once. We used to be faithful about it, but since Father went away and all this war trouble unsettled us, we have neglected many things. You can do as you please, but I shall keep my book on the table here and read a little every morning as soon as I wake, for I know it will do me good and help me through the day."

Then she opened her new book and began to read. Jo put her arm round her and, leaning cheek to cheek, read also, with the quiet expression so seldom seen on her restless face.

"How good Meg is! Come, Amy, let's do as they do. I'll help you with the hard words, and they'll explain things if we don't understand," whispered Beth, very much impressed by the pretty books and her sisters' example.

"I'm glad mine is blue," said Amy. And then the rooms were very still while the pages were softly turned, and the winter sunshine crept in to touch the bright heads and serious faces with a Christmas greeting.

"Where is Mother?" asked Meg, as she and Jo ran down to thank her for their gifts, half an hour later.

"Goodness only knows. Some poor creeter come a-beggin', and your ma went straight off to see what was needed. There never *was* such a woman for givin' away vittles and drink, clothes and firin'," replied Hannah, who had lived with the family since Meg was born, and was considered by them all more as a friend than a servant.

"She will be back soon, I think, so fry your cakes, and have everything ready," said Meg, looking over the presents which were collected in a basket and kept under the sofa, ready to be produced at the proper time. "Why, where is Amy's bottle of cologne?" she added, as the little flask did not appear.

"She took it out a minute ago, and went off with it to put a ribbon on it, or some such notion," replied Jo, dancing about the room to take the first stiffness off the new army slippers.

"How nice my handkerchiefs look, don't they? Hannah washed and ironed them for me, and I marked them all myself," said Beth, looking proudly at the somewhat uneven letters which had cost her such labor.

"Bless the child! She's gone and put 'Mother' on them instead of 'M. march.' How funny!" cried Jo, taking up one.

"Isn't it right? I thought it was better to do it so, because Meg's initials are M. M., and I don't want anyone to use these but Marmee," said Beth, looking troubled.

"It's all right, dear, and a very pretty idea—quite sensible, too, for no one can ever mistake now.

It will please her very much, I know," said Meg, with a frown for Jo and a smile for Beth.

"There's Mother. Hide the basket, quick!" cried Jo, as a door slammed and steps sounded in the hall.

Amy came in hastily, and looked rather abashed when she saw her sisters all waiting for her.

"Where have you been, and what are you hiding behind you?" asked Meg, surprised to see, by her hood and cloak, that lazy Amy had been out so early.

"Don't laugh at me, Jo! I didn't mean anyone should know till the time came. I only meant to change the little bottle for a big one, and I gave *all* my money to get it, and I'm truly trying not to be selfish any more."

As she spoke, Amy showed the handsome flask which replaced the cheap one, and looked so earnest and humble in her little effort to forget herself that Meg hugged her on the spot, and Jo pronounced her "a trump," while Beth ran to the window, and picked her finest rose to ornament the stately bottle.

"You see I felt ashamed of my present, after reading and talking about being good this morning, so I ran round the corner and changed it the minute I was up: and I'm so glad, for mine is the handsomest now."

Another bang of the street door sent the basket under the sofa, and the girls to the table, eager for breakfast.

"Merry Christmas, Marmee! Many of them! Thank you for our books; we read some, and mean to every day," they cried, in chorus.

"Merry Christmas, little daughters! I'm glad you began at once, and hope you will keep on. But I want to say one word before we sit down. Not far away from here lies a poor woman with a little newborn baby. Six children are huddled into one bed to keep from freezing, for they have no fire. There is nothing to eat over there, and the oldest boy came to tell me they were suffering hunger and cold. My girls, will you give them your breakfast as a Christmas present?"

They were all unusually hungry, having waited nearly an hour, and for a minute no one spoke—only a minute, for Jo exclaimed impetuously, "I'm so glad you came before we began!"

"May I go and help carry the things to the poor little children?" asked Beth eagerly.

"I shall take the cream and the muffins," added Amy, heroically giving up the articles she most liked.

Meg was already covering the buckwheats, and piling the bread into one big plate.

"I thought you'd do it," said Mrs. March, smiling as if satisfied. "You shall all go and help me, and when we come back we will have bread and milk for breakfast, and make it up at dinnertime."

They were soon ready, and the procession set out. Fortunately it was early, and they went through back streets, so few people saw them, and no one laughed at the queer party.

A poor, bare, miserable room it was, with broken windows, no fire, ragged bedclothes, a sick mother,

wailing baby, and a group of pale, hungry children cuddled under one old quilt, trying to keep warm.

How the big eyes stared and the blue lips smiled as the girls went in!

"*Ach, mein Gott!* It is good angels come to us!" said the poor woman, crying for joy.

"Funny angels in hoods and mittens," said Jo, and set them laughing.

In a few minutes it really did seem as if kind spirits had been at work there. Hannah, who had carried wood, made a fire, and stopped up the broken panes with old hats and her own cloak. Mrs. March gave the mother tea and gruel, and comforted her with promises of help, while she dressed the little baby as tenderly as if it had been her own. The girls meantime spread the table, set the children round the fire, and fed them like so many hungry birds—laughing, talking, and trying to understand the funny broken English.

"*Das ist gut!*" "*Die Engel-kinder!*" cried the poor things as they ate and warmed their purple hands at the comfortable blaze.

The girls had never been called angel children before, and thought it very agreeable, especially Jo, who had been considered a "Sancho" ever since she was born. That was a very happy breakfast, though they didn't get any of it; and when they went away, leaving comfort behind, I think there were not in all the city four merrier people than the hungry little girls who gave away their breakfasts and

contented themselves with bread and milk on Christmas morning.

"That's loving our neighbor better than ourselves, and I like it," said Meg, as they set out their presents while their mother was upstairs collecting clothes for the poor Hummels.

Not a very splendid show, but there was a great deal of love done up in the few little bundles, and the tall vase of red roses, white chrysanthemums, and trailing vines, which stood in the middle, gave quite an elegant air to the table.

"She's coming! Strike up, Beth! Open the door, Amy! Three cheers for Marmee!" cried Jo, prancing about while Meg went to conduct Mother to the seat of honor.

Beth played her gayest march,

Amy threw open the door, and Meg enacted escort with great dignity. Mrs. March was both surprised and touched, and smiled with her eyes full as she examined her presents and read the little notes which accompanied them. The slippers went on at once, a new handkerchief was slipped into her pocket, well scented with Amy's cologne, the rose was fastened in her bosom, and the nice gloves were pronounced a "perfect fit."

There was a good deal of laughing and kissing and explaining, in the simple, loving fashion which makes these home festivals so pleasant at the time, so sweet to remember long afterward, and then all fell to work.

The morning charities and ceremonies took so much time that

the rest of the day was devoted to preparations for the evening festivities. Being still too young to go often to the theater, and not rich enough to afford any great outlay for private performances, the girls put their wits to work, and—necessity being the mother of invention—made whatever they needed. Very clever were some of their productions—pastboard guitars, antique lamps made of old-fashioned butter boats covered with silver paper, gorgeous robes of old cotton, glittering with tin spangles from a pickle factory, and armor covered with the same useful diamond-shaped bits left in sheets when the lids of tin preserve pots were cut out. The furniture was used to being turned topsy-turvy, and the big chamber was the scene of many innocent revels.

No gentlemen were admitted, so Jo played male parts to her heart's content and took immense satisfaction in a pair of russet-leather boots given her by a friend, who knew a lady who knew an actor. These boots, in old foil, and a slashed doublet once used by an artist for some picture, were Jo's chief treasures and appeared on all occasions. The smallness of the company made it necessary for the two principal actors to take several parts apiece, and they certainly deserved some credit for the hard work they did in learning three or four different parts, whisking in and out of various costumes, and managing the stage besides. It was excellent drill for their memories, a harmless amusement, and employed many hours which otherwise would have

been idle, lonely, or spent in less profitable society.

On Christmas night, a dozen girls piled onto the bed which was the dress circle, and sat before the blue and yellow chintz curtains in a most flattering state of expectancy. There was a good deal of rustling and whispering behind the curtain, a trifle of lamp smoke, and an occasional giggle from Amy, who was apt to get hysterical in the excitement of the moment. Presently a bell sounded, the curtains flew apart, and the Operatic Tragedy began.

"A gloomy wood," according to the one playbill, was represented by a few scrubs in pots, green baize on the floor, and a cave in the distance. This cave was made with a clotheshorse for a roof, bureaus for walls, and in it was a small furnace in full blast, with a black pot on it and an old witch bending over it. The stage was dark and the glow of the furnace had a fine effect, especially as real steam issued from the kettle when the witch took off the cover. A moment was allowed for the first thrill to subside, then Hugo, the villain, stalked in with a clanking sword at his side, a slouched hat, black beard, mysterious cloak, and the boots. After pacing to and fro in much agitation, he struck his forehead, and burst out in a wild strain, singing of his hatred of Roderigo, his love for Zara, and his pleasing resolution to kill the one and win the other. The gruff tones of Hugo's voice, with an occasional shout when his feelings overcame him, were very impressive, and the audience

applauded the moment he paused for breath. Bowing with the air of one accustomed to public praise, he stole to the cavern and ordered Hagar to come forth with a commanding, "What ho, minion! I need thee!"

Out came Meg, with gray horsehair hanging about her face, a red and black robe, a staff, and cabalistic signs upon her cloak. Hugo demanded a potion to make Zara adore him, and one to destroy Roderigo. Hagar, in a fine dramatic melody, promised both, and proceeded to call up the spirit who would bring the love philter:

Hither, hither, from thy home,
Airy sprite, I bid thee come!
Born of roses, fed on dew,
Charms and potions canst thou
 brew?

Bring me here, with elfin speed,
The fragrant philter which I
 need;
Make it sweet and swift and
 strong,
Spirit, answer now my song!

A soft strain of music sounded, and then at the back of the cave appeared a little figure in cloudy white, with glittering wings, golden hair, and a garland of roses on its head. Waving a wand, it sang,

Higher I come,
From my airy home,
Afar in the silver moon.
Take the magic spell,
And use it well,
Or its power will vanish soon!

And dropping a small, gilded bottle at the witch's feet, the spirit

vanished. Another chant from Hagar produced another apparition—not a lovely one, for with a bang an ugly black imp appeared and, having croaked a reply, tossed a dark bottle at Hugo and disappeared with a mocking laugh. Having warbled his thanks and put the potions in his boots, Hugo departed, and Hagar informed the audience that, as he had killed a few of her friends in times past, she has cursed him, and intends to thwart his plans, and be revenged on him. Then the curtain fell, and the audience reposed and ate candy while discussing the merits of the play.

A good deal of hammering went on before the curtain rose again, but when it became evident what a masterpiece of stage carpentering

had been got up, no one murmured at the delay. It was truly superb! A tower rose to the ceiling; halfway up appeared a window with a lamp burning at it, and behind the white curtain appeared Zara in a lovely blue and silver dress, waiting for Roderigo. He came in gorgeous array, with plumed cap, red cloak, chestnut lovelocks, a guitar, and the boots, of course. Kneeling at the foot of the tower, he sang a serenade in melting tones. Zara replied and, after a musical dialogue, consented to fly. Then came the grand effect of the play. Roderigo produced a rope ladder, with five steps to it, threw up one end, and invited Zara to descend. Timidly she crept from her lattice, put her hand on Roderigo's shoulder, and was about to leap gracefully down when "Alas! alas

for Zara!" she forgot her train—it caught in the window, the tower tottered, leaned forward, fell with a crash, and buried the unhappy lovers in the ruins!

A universal shriek arose as the russet boots waved wildly from the wreck and a golden head emerged, exclaiming, "I told you so! I told you so!" With wonderful presence of mind, Don Pedro, the cruel sire, rushed in, dragged out his daughter, with a hasty aside—

"Don't laugh! Act as if it was all right!"—and, ordering Roderigo up, banished him from the kingdom with wrath and scorn. Though decidedly shaken by the fall of the tower upon him, Roderigo defied the old gentleman and refused to stir. This dauntless example fired Zara: she also defied her sire, and he ordered them both

to the deepest dungeons of the castle. A stout little retainer came in with chains and led them away, looking very much frightened and evidently forgetting the speech he ought to have made.

Act third was the castle hall, and here Hagar appeared, having come to free the lovers and finish Hugo. She hears him coming and hides, sees him put the potions into two cups of wine and bid the timid little servant, "Bear them to the captives in their cells, and tell them I shall come anon." The servant takes Hugo aside to tell him something, and Hagar changes the cups for two others which are harmless. Ferdinando, the "Minion," carries them away, and Hagar puts back the cup which holds the poison meant for Roderigo. Hugo, getting thirsty

after a long warble, drinks it, loses his sits, and after a good deal of clutching and stamping, falls flat and dies, while Hagar informs him what she has done in a song of exquisite power and melody.

This was a truly thrilling scene, though some persons might have thought that the sudden tumbling down of a quantity of long hair rather marred the effect of the villain's death. He was called before the curtain, and with great propriety appeared, leading Hagar, whose singing was considered more wonderful than all the rest of the performance put together.

Act fourth displayed the despairing Roderigo on the point of stabbing himself because he has been told that Zara has deserted him. Just as the dagger is at his heart, a lovely song is sung under his window, informing him that Zara is true but in danger, and he can save her if he will. A key is thrown in, which unlocks the door, and in a spasm of rapture he tears off his chains and rushes away to find and rescue his lady-love.

Act fifth opened with a stormy scene between Zara and Don Pedro. He wishes her to go into a convent, but she won't hear of it and, after a touching appeal, is about to faint when Roderigo dashes in and demands her hand. Don Pedro refuses, because he is not rich. They shout and gesticulate tremendously but cannot agree, and Roderigo is about to bear away the exhausted Zara, when the timid servant enters with a letter and a bag from Hagar, who has mysteriously disappeared. The latter informs

the party that she bequeaths untold wealth to the young pair and an awful doom to Don Pedro, if he doesn't make them happy. The bag is opened, and several quarts of tin money shower down upon the stage till it is quite glorified with the glitter. This entirely softens the "stern sire." He consents without a murmur, all join in a joyful chorus, and the curtain falls upon the lovers kneeling to receive Don Pedro's blessing in attitudes of the most romantic grace.

Tumultuous applause followed but received an unexpected check, for the cot bed, on which the "dress circle" was built, suddenly shut up and extinguished the enthusiastic audience. Roderigo and Don Pedro flew to the rescue, and all were taken out unhurt,

though many were speechless with laughter. The excitement had hardly subsided when Hannah appeared, with "Mrs. March's compliments, and would the ladies walk down to supper."

This was a surprise even to the actors, and when they saw the table, they looked at one another in rapturous amazement. It was like Marmee to get up a little treat for them, but anything so fine as this was unheard of since the departed days of plenty. There was ice cream—actually two dishes of it, pink and white—and cake and fruit and distracting French bonbons and, in the middle of the table, four great bouquets of hothouse flowers!

It quite took their breath away; and they stared first at the table and then at their mother, who

looked as if she enjoyed it immensely.

"Is it fairies?" asked Amy.

"It's Santa Claus," said Beth.

"Mother did it." And Meg smiled her sweetest, in spite of her gray beard and white eyebrows.

"Aunt March had a good fit and sent the supper," cried Jo, with a sudden inspiration.

"All wrong. Old Mr. Laurence sent it," replied Mrs. March.

"The Laurence boy's grandfather! What in the world put such a thing into his head? We don't know him!" exclaimed Meg.

"Hannah told one of his servants about your breakfast party. He is an odd old gentleman, but that pleased him. He knew my father years ago, and he sent me a polite note this afternoon, saying he hoped I would allow him to express his friendly feeling toward my children by sending them a few trifles in honor of the day. I could not refuse, and so you have a little feast at night to make up for the bread-and-milk breakfast."

"That boy put it into his head, I know he did! He's a capital fellow, and I wish we could get acquainted. He looks as if he'd like to know us but he's bashful, and Meg is so prim she won't let me speak to him when we pass," said Jo, as the plates went round, and the ice began to melt out of sight, with ohs and ahs of satisfaction.

"You mean the people who live in the big house next door, don't you?" asked one of the girls. "My mother knows old Mr. Laurence, but says he's very proud and doesn't like to mix with his

neighbors. He keeps his grandson shut up, when he isn't riding or walking with his tutor, and makes him study very hard. We invited him to our party, but he didn't come. Mother says he's very nice, though he never speaks to us girls."

"Our cat ran away once, and he brought her back, and we talked over the fence, and were getting on capitally—all about cricket, and so on—when he saw Meg coming, and walked off. I mean to know him some day, for he needs fun, I'm sure he does," said Jo decidedly.

"I like his manners, and he looks like a little gentleman; so I've no objection to your knowing him, if a proper opportunity comes. He brought the flowers himself, and I should have asked him in, if I had been sure what was going on upstairs. He looked so wistful as he went away, hearing the frolic and evidently having none of his own."

"It's a mercy you didn't, Mother!" laughed Jo, looking at her boots. "But we'll have another play sometime that he can see. Perhaps he'll help act. Wouldn't that be jolly?"

"I never had such a fine bouquet before! How pretty it is!" And Meg examined her flowers with great interest.

"They are lovely! But Beth's roses are sweeter to me," said Mrs. March, smelling the half-dead posy in her belt.

Beth nestled up to her, and whispered softly, "I wish I could send my bunch to Father. I'm afraid he isn't having such a merry Christmas as we are."

Christmas Pudding

Serve hot with brandy butter

1 CUP RAISINS
1 CUP SULTANAS
1 CUP CURRANTS
1/2 CUP CHERRIES
1/2 CUP CANDIED PEEL
1 CUP BROWN SUGAR
1 CUP FRESH BREAD CRUMBS
1 CUP FINELY-CHOPPED BEEF SUET
1 COOKING APPLE, GRATED
4 EGGS
GRATED RIND & JUICE OF 1
 LEMON
GRATED RIND & JUICE OF 1 ORANGE
3 CUPS RUM
1/2 CUP GROUND ALMONDS
3 TEASPOONS NUTMEG
3 TEASPOONS GROUND CLOVES

1. Mix all ingredients together and leave overnight. According to tradition, everyone in the family should stir and make a wish.

2. Next day, stir again for good measure. Fill into pudding bowls; cover with a double thickness of greaseproof paper which has been pleated in the center, and tie it tightly under the rim with cotton twine, making a twine handle also for ease of lifting.

3. Steam in a covered saucepan of boiling water for 6 hours. The water should come halfway up the side of the bowl. Check every hour or so and top up with boiling water if necessary.

4. After 6 hours, remove the pudding from stove and allow to cool. Cover with fresh wax paper and store in a cool dry place until ready to serve.

5. On Christmas Day, steam for a further 2 hours. Serve hot on a very hot serving plate. Pour some whiskey or brandy over the pudding and ignite. Serve immediately with brandy butter or whipped cream.

Yes, Virginia, There Is a Santa Claus

FRANCIS P. CHURCH

Dear Editor:
I am 8 years old. Some of my friends say there is no Santa Claus. Papa says "If you see it in *The Sun* it's so." Please tell me the truth; is there a Santa Claus?
Virginia O'Hanlon

Virginia, your little friends are wrong. They have been affected by the skepticism of a skeptical age. They do not believe except they see. They think that nothing can be which is not comprehensible by their little minds. All minds, Virginia, whether they be men's or children's, are little. In this great universe of ours man is a mere insect, an

ant, in his intellect, as compared with the boundless world about him, as measured by the intelligence capable of grasping the whole of truth and knowledge.

Yes, Virginia, there is a Santa Claus. He exists as certainly as love and generosity and devotion exist, and you know that they abound and give to your life its highest beauty and joy. Alas! how dreary would be the world if there were no Santa Claus! It would be as dreary as if there were no Virginias. There would be no childlike faith then, no poetry, no romance to make tolerable this existence. We should have no enjoyment, except in sense and sight. The eternal light with which childhood fills the world would be extinguished.

Not believe in Santa Claus! You might as well not believe in fairies! You might get your papa to hire men to watch in all the chimneys on Christmas Eve to catch Santa Claus, but even if they did not see Santa Claus coming down, what would that prove? Nobody sees Santa Claus, but that is no sign that there is no Santa Claus. The most real things in the world are those that neither children nor men can see.

No Santa Claus! Thank God, he lives, and he lives forever. A thousand years from now, Virginia, nay, ten times ten thousand years from now, he will continue to make glad the heart of childhood.

—*The New York Sun*,
September 21, 1897

Peppermint Meringues

4 EGG WHITES (APPROX. $1/2$ CUP)
$1/2$ TEASPOON CREAM OF TARTAR
$3/4$ CUP WHITE SUGAR
$3/4$ CUP CONFECTIONERS' SUGAR
$1/4$ TEASPOON IMITATION
 PEPPERMINT EXTRACT (NO
 PEPPERMINT OIL IN IT!)
RED AND GREEN FOOD COLORING

1. Preheat the oven to 200°F. Line two large cookie sheets with parchment or foil.
2. In a copper or stainless steel mixing bowl, beat the egg whites until frothy. Add the cream of tartar and beat at medium speed while gradually adding 1 tablespoon of the sugar. When soft peaks begin to form, add the rest of the sugar and the peppermint extract slowly, and beat at high speed until stiff peaks form when the beater is raised.
3. Fit large decorating bag (a 14-inch one is perfect) with large round tip ($1/2$ to $3/4$-inch diameter). Brush four thin lines of red food coloring lengthwise on inside of bag. Carefully fill decorating bag with half of the meringue. Do another bag with green food coloring.
4. Pipe meringue directly onto the parchment on the cookie sheets or make shapes with your meringues (peppermint sticks, wreaths, moons), or divide your meringue in half and spoon it into two equal circles onto the parchment (the size of a cake, if

you like). When you have finished baking, you can put sliced strawberries and whipped cream (or whipped cream and chocolate sauce) on top of one circle then top with the other meringue. Or you can build little peppermint meringue bowls and bake that way, filling the bowls with ice cream and chocolate sauce later. And if you like, you can just crumble up the individual meringues and mix them with whipped cream and chocolate sauce.

5. In any and all cases, bake for 2–2 1/2 hours. Leave meringues in the oven while they cool down, and don't let them brown. If your oven has a pilot light, an even better way is to make the meringues the night before is to bake them for 1 hour at 200°F, then turn off the oven and leave theminside the oven until morning. They will be perfect.

Makes 20–25 meringues

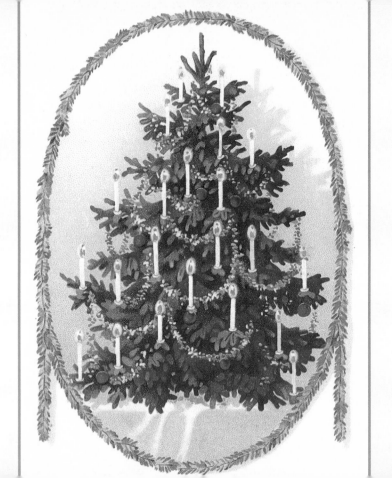

A Christmas Tree

CHARLES DICKENS

I have been looking on, this evening, at a merry company of children assembled round that pretty German toy, a Christmas tree. The tree was planted in the middle of a great round table, and towered high above their heads. It was brilliantly lighted by a multitude of little tapers and everywhere sparkled and glittered with bright objects. There were rosy-cheeked dolls, hiding behind the green leaves; there were real watches (with movable hands, at least, and an endless capacity of being wound up) dangling from innumerable twigs; there were French-polished tables, chairs, bedsteads, wardrobes, eight-day clocks, and various other articles of domestic furniture (wonderfully made, in tin, at Wolverhampton), perched among the boughs, as if in preparation for some fairy housekeeping; there were jolly, broad-faced little men, much more agreeable in appearance than many real men—and no wonder, for their heads came off, and showed them to be full of sugarplums; there were fiddles and drums; there were tambourines, books, workboxes, paint boxes, sweetmeat boxes, peep-show boxes, and all kinds of boxes; there

were trinkets for the elder girls, far brighter than any grown-up gold and jewels . . . there were guns, swords and banners . . . pen wipers, smelling bottles . . . real fruit . . . imitation apples, pears and walnuts, crammed with surprises; in short, as a pretty child, before me delightedly whispered to another pretty child, "There was everything and more."

Being now at home again, and alone, the only person in the house awake, my thoughts are drawn back, by a fascination which I do not care to resist, to my own childhood. I begin to consider, what do we all remember best upon the branches of the Christmas tree of our own young Christmas days, by which we climbed to real life?

STRAIGHT, IN THE MIDDLE OF THE ROOM, cramped in the freedom of its growth by now encircling walls or soon-reached ceiling, a shadowy tree arises; and, looking up into the dreamy brightness of its top—for I observe in this tree the singular property that it appears to grow downward toward the earth—I look into my youngest Christmas recollection. . . .

I see a wonderful row of little lights rise smoothly out of the ground, before a vast green curtain. Now a bell rings—a magic bell, which still sounds in my ears unlike all other bells—and music plays, amid a buzz of voices, and a fragrant smell of orange peel. Anon, the magic bell commands the music to cease, and the great green curtain rolls itself up majestically, and The Play begins. . . . Out of this delight springs the toy

theater—there it is, with its familiar proscenium, and ladies in feathers, in the boxes!—and all its attendant occupation with paste and glue, and gum, and water colors, in the getting up of the Miller and His Man. . . .

Vast is the crop of such fruit, shining on our Christmas tree; in blossom, almost at the very tops ripening all down the boughs!

Among the later toys and fancies hanging there—as idle often and less pure—be the images once associated with the sweet old Waits, the softened music in the night, ever unalterable! Encircled by the social thoughts of Christmastime, still let the benignant figure of my childhood stand unchanged! In every cheerful image and suggestion that the season brings, may the bright star that rested above the poor roof be the star of all the Christian world! A moment's pause, O vanishing tree, of which the lower branches are dark to me as yet, and let me look once more! I know there are blank spaces on thy branches, where eyes that I have loved have looked and smiled; from which they are departed. But far above, I see the raiser of the dead girl, and the widow's son; and God is good! If age be hiding for me in the unseen portion of thy downward growth, O may I, with a gray head, turn a child's heart to that figure yet, and a child's trustfulness and confidence!

NOW, THE TREE IS DECORATED with bright merriment, and song, and dance, and cheerfulness. And they are welcome be they ever held, beneath the branches of the Christmas tree, which cast no gloomy shadow.

Apple Cider with Cinnamon Sticks

1 QUART (4 CUPS) APPLE CIDER
(OR APPLE JUICE)
PEEL FROM $1/2$ ORANGE
1 1-INCH PIECE FRESH GINGER,
PEELED AND SLICED
1 TEASPOON ALLSPICE
6 CINNAMON STICKS
ADDITIONAL CINNAMON STICKS, ONE
PER CUP (KIDS LOVE TO TRY TO
USE THESE AS STRAWS!)

1. Warm the apple juice or cider in a large saucepan over the lowest heat.
2. Wrap up the remaining ingredients in a big piece of cheesecloth and add it to the pot—or put them in a strainer that hooks over the pot and hangs down into the liquid. Simmer at the lowest heat for 4 to 5 hours.
3. Throw away the spices, pour the cider into mugs, and add a cinnamon stick, if desired.

Christmas at Hyde Park

ELEANOR ROOSEVELT

When our children were young, we spent nearly every Christmas holiday at Hyde Park. We always had a party the afternoon of Christmas Eve for all the families who lived on the place. The presents were piled under the tree, and after everyone had been greeted, my husband would choose the children old enough to distribute gifts and send them around to the guests. My mother-in-law herself always gave out her envelopes with money, and I would give out ours. The cornucopias filled with old-fashioned sugar candies and the peppermint canes hanging on the trees were distributed, too, and then our guests would leave us and enjoy their ice cream, cake, and coffee or milk in another room. Later in the day, when the guests had departed, my husband would begin the reading of *A Christmas Carol*. He never read it through; but he would select parts he thought suitable for the youngest members of the family. Then, after supper, he would read other parts for the older ones.

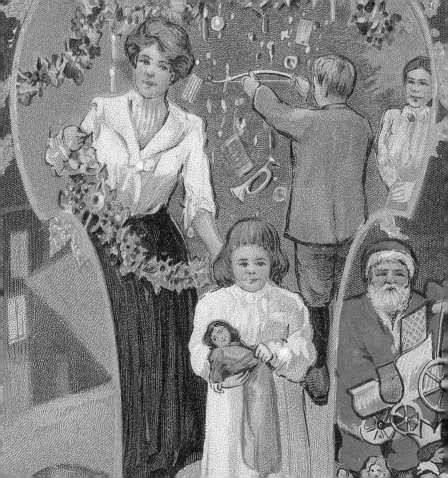

On Christmas morning, I would get up and close the windows in our room, where all the stockings had been hung on the mantel. The little children would be put into our bed and given their stockings to open. The others would sit around the fire. I tried to see that they all had a glass of orange juice before the opening of stockings really began, but the excitement was so great I was not always successful.

Breakfast was late Christmas morning, and my husband resented having to go to church on Christmas Day and sometimes flatly refused to attend. But I would go with my mother-in-law and such children as she could persuade to accompany us. For the most part, however, the children stayed home. In later years, I went to midnight service on Christmas Eve, and we gave up going to church in the morning.

I remembered the excitement as each child grew old enough to have his own sled and would start out after breakfast to try it on the hill behind the stable. Franklin would go coasting with them, and until the children were nearly grown, he was the only one who ever piloted the bobsled down the hill. Everyone came in for a late lunch, and at dusk we would light the candles on the tree again. Only outdoor presents like sleds and skates were distributed in the morning. The rest were kept for the late-afternoon Christmas tree. Again they were piled under the tree, and my husband and the children scrambled around it, and he called the names.

At first, my mother-in-law did a great deal of shopping and wrapping, and the Hyde Park Christmas always included her gifts. Later, she found shopping too difficult. Then she would give each person a check, though she managed very often to give her son the two things she knew he would not buy for himself—silk shirts and silk pajamas. These she bought in London, as a rule, and saved for his Christmas, which to her was always very special.

In the early years of our marriage, I did a great deal more sewing and embroidering than I've done since, so many of my gifts were things I had made. The family still has a few pieces of Italian cutwork embroidery and other kinds of my perfectly useless handwork. I look back, however, with some pleasure on the early Hyde Park days, when I would have a table filled with pieces of silk and make sachets of different scents. I would dry pine needles at Campobello Island and make them into sweet-smelling bags for Christmas. Now I rarely give a present I have made, and perhaps, it is just as well, for what one buys is likely to be better made!

Each of the children had a special preference in gifts. When Anna was a small child, her favorite present was a rocking horse, on which she spent many hours. Later, she was to spend even more hours training her own horse, which her great-uncle Mr. Warren Delano gave her. One of the nicest gifts we could possibly give her as she grew older was something for her horse,

Natomah. Jimmy loved boats from the very beginning, whether he floated them in the bathtub or later competed with his father in the regattas of toy boats on the Hudson River. Elliott was always trying to catch up with his older brother and sister; but because he was delicate as a child, I think he read more than the others. I remember that books and games were very acceptable gifts for him. Franklin, Jr., and John were a pair and had to have pretty much the same things, or they would quarrel over them. They had learned together to ride and to swim, so gifts for outdoor sports were always favorites of theirs.

My children teased me because their stockings inevitably contained toothbrushes, toothpaste, nail cleaners, soap, washcloths, etc. They said Mother never ceased to remind them that cleanliness was next to godliness—even on Christmas morning. In the toe of each stocking, I always put a purse, with a dollar bill for the young ones and a five-dollar bill for the older ones. These bills were hoarded to supplement the rather meager allowances they had. When I was able to buy sucre d'orge (barley sugar), I put that in their stockings, together with some old-fashioned peppermint sticks; but as they grew older, this confection seemed to vanish from the market, and I had to give it up and substitute chocolates. The stockings also contained families of little china pigs or rabbits or horses, which the children placed on their bookshelves.

The children themselves could probably tell much better than I can the things they remember most about these years. But I know that all of them have carried on many of the Hyde Park Christmas traditions with their children. Today, some of my grandchildren are establishing the same customs, and my great-grandchildren will one day remember the same kind of Christmas we started so many years ago.

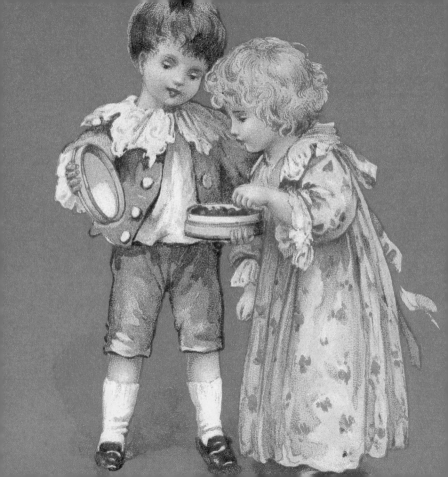

Apple Cranberry Oatmeal Pie

CRUST

1 1/2 CUPS ROLLED OATS
1/2 CUP WHITE FLOUR
1/4 TEASPOON SALT
3 TABLESPOONS BROWN SUGAR
1 STICK MELTED BUTTER

FILLING

6 CUPS (APPROX. 4) TART APPLES,
 PEELED AND SLICED
2 CUPS FRESH OR FROZEN
 CRANBERRIES
3 TABLESPOONS LEMON JUICE
1 TEASPOON GRATED LEMON RIND
2 TABLESPOONS WHITE FLOUR
1/4 CUP BROWN SUGAR
1/2 CUP SOUR CREAM
1/4 CUP CHOPPED WALNUTS

1. Combine all of the crust ingredients in a medium-sized bowl and mix well.
2. Press firmly into the bottom and sides of a 9- or 10-inch pie pan, forming a thick crust. Reserve a handful of the crust for the topping.
3. Preheat oven to 375°F.
4. Toss apples and cranberries with lemon juice; add spices and lemon rind, and finally sugar, cream, and nuts.
5. Fill crust with fruite mixture and sprinkle the reserved crust over the top.
6. Bake 50 minutes or until browned. If pie gets brown too fast, cover loosely with tinfoil.

Traditional Sugar Cookies

1 CUP BUTTER (2 STICKS), AT
 ROOM TEMPERATURE
1 CUP SUGAR
2 EGGS
1 TEASPOON VANILLA EXTRACT
3 CUPS FLOUR

1. Cream together butter and sugar. Beat in the eggs and add the vanilla. Add the flour and mix well. Refrigerate for at least 2 hours.

2. Preheat the oven to 375°F and line baking sheets with parchment paper.

3. Roll the dough out on a lightly floured surface (marble or wood) and cut with a cookie cutter. Transfer the cookies to cookie sheets with a spatula. If you are going to decorate without icing, decorate with sprinkles and move the sheets into the oven.

4. Bake approximately 10 minutes. When cookies begin to brown, remove them from the oven and slide the parchment off the baking sheet. When cookies have cooled a bit, slide them off the parchment. Be sure to cool cookie sheets before using them again.

The Gift of the Magi

O. Henry

One dollar and eighty-seven cents. That was all. And sixty cents of it was in pennies. Pennies saved one and two at a time by bulldozing the grocer and the vegetable man and the butcher until one's cheeks burned with the silent imputation of parsimony that such close dealing implied. Three times Della counted it. One dollar and eighty-seven cents. And the next day would be Christmas.

There was clearly nothing to do but flop down on the shabby little couch and howl. So Della did it. Which instigates the moral reflection that life is made up of sobs, sniffles, and smiles, with sniffles predominating.

While the mistress of the home is gradually subsiding from the first stage to the second, take a look at the home. A furnished flat at $8 per week. It did not exactly beggar description, but it certainly had that word on the lookout for the mendicancy squad.

In the vestibule below was a letter-box into which no letter would go, and an electric button from which no mortal finger could coax a ring. Also appertaining thereunto was a card bearing the

name "Mr. James Dillingham Young."

The "Dillingham" had been flung to the breeze during a former period of prosperity when its possessor was being paid $30 per week. Now, when the income was shrunk to $20, the letters of "Dillingham" looked blurred, as though they were thinking seriously of contracting to a modest and unassuming D. But whenever Mr. James Dillingham Young came home and reached his flat above he was called "Jim" and greatly hugged by Mrs. James Dillingham Young, already introduced to you as Della. Which is all very good.

Della finished her cry and attended to her cheeks with the powder rag. She stood by the window and looked out dully at a grey cat walking a grey fence in a grey backyard. To-morrow would be Christmas Day, and she had only $1.87 with which to buy Jim a present. She had been saving every penny she could for months, with this result. Twenty dollars a week doesn't go far. Expenses had been greater than she had calculated. They always are. Only $1.87 to buy a present for Jim. Her Jim. Many a happy hour she had spent planning for something nice for him. Something fine and rare and sterling—something just a little bit near to being worthy of the honour of being owned by Jim.

There was a pier-glass between the windows of the room. Perhaps you have seen a pier-glass in an $8 flat. A very thin and very agile person may, by observing his

reflection in a rapid sequence of longitudinal strips, obtain a fairly accurate conception of his looks. Della, being slender, had mastered the art.

Suddenly she whirled from the window and stood before the glass. Her eyes were shining brilliantly, but her face had lost its colour within twenty seconds. Rapidly she pulled down her hair and let it fall to its full length.

Now, there were two possessions of the James Dillingham Youngs in which they both took a mighty pride. One was Jim's gold watch that had been his father's and grandfather's. The other was Della's hair. Had the Queen of Sheba lived in the flat across the airshaft, Della would have let her hair hang out the window some

day to dry just to depreciate Her Majesty's jewels and gifts. Had King Solomon been the janitor, with all his treasures piled up in the basement, Jim would have pulled out his watch every time he passed, just to see him pluck at his beard from envy.

So now Della's beautiful hair fell about her, rippling and shining like a cascade of brown waters. It reached below her knee and made itself almost a garment for her. And then she did it up again nervously and quickly. Once she faltered for a minute and stood still while a tear or two splashed on the worn red carpet.

On went her old brown jacket; on went her old brown hat. With a whirl of skirts and with the brilliant sparkle still in her eyes, she fluttered out the door and

down the stairs to the street.

Where she stopped the sign read: "Mme. Sofronie. Hair Goods of All Kinds." One flight up Della ran, and collected herself, panting. Madame, large, too white, chilly, hardly looked the "Sofronie."

"Will you buy my hair?" asked Della.

"I buy hair," said Madame. "Take yer hat off and let's have a sight at the looks of it."

Down rippled the brown cascade.

"Twenty dollars," said Madame, lifting the mass with a practised hand.

"Give it to me quick," said Della.

Oh, and the next two hours tripped by on rosy wings. Forget the hashed metaphor. She was ransacking the stores for Jim's present.

She found it at last. It surely had been made for Jim and no one else. There was no other like it in any of the stores, and she had turned all of them inside out. It was a platinum fob chain simple and chaste in design, properly proclaiming its value by substance alone and not by meretricious ornamentation—as all good things should do. It was even worthy of The Watch. As soon as she saw it she knew that it must be Jim's. It was like him. Quietness and value—the description applied to both. Twenty-one dollars they took from her for it, and she hurried home with the 87 cents. With that chain on his watch Jim might be properly anxious about the time in any company. Grand as

the watch was, he sometimes looked at it on the sly on account of the old leather strap that he used in place of a chain.

When Della reached home her intoxication gave way a little to prudence and reason. She got out her curling irons and lighted the gas and went to work repairing the ravages made by generosity added to love. Which is always a tremendous task, dear friends—a mammoth task.

Within forty minutes her head was covered with tiny close-lying curls that made her look wonderfully like a truant schoolboy. She looked at her reflection in the mirror long, carefully, and critically.

"If Jim doesn't kill me," she said to herself, "before he takes a second look at me, he'll say I look like a Coney Island chorus girl. But what could I do—oh! what could I do with a dollar and eighty-seven cents?"

At 7 o'clock the coffee was made and the frying-pan was on the back of the stove hot and ready to cook the chops.

Jim was never late. Della doubled the fob chain in her hand and sat on the corner of the table near the door that he always entered. Then she heard his step on the stair away down on the first flight, and she turned white for just a moment. She had a habit of saying little silent prayers about the simplest everyday things, and now she whispered: "Please God, make him think I am still pretty."

The door opened and Jim stepped in and closed it. He looked thin and very serious. Poor

fellow, he was only twenty-two—
and to be burdened with a family!
He needed a new overcoat and he
was without gloves.

Jim stopped inside the door, as
immovable as a setter at the scent
of quail. His eyes were fixed upon
Della, and there was an expression
in them that she could not read,
and it terrified her. It was not
anger, nor surprise, nor
disapproval, nor horror, nor any
of the sentiments that she had
been prepared for. He simply
stared at her fixedly with that
peculiar expression on his face.

Della wriggled off the table and
went for him.

"Jim, darling," she cried, "don't
look at me that way. I had my hair
cut off and sold it because I
couldn't have lived through
Christmas without giving you a

present. It'll grow out again—you
won't mind, will you? I just had to
do it. My hair grows awfully fast.
Say 'Merry Christmas!' Jim, and
let's be happy. You don't know
what a nice—what a beautiful,
nice gift I've got for you."

"You've cut off your hair?"
asked Jim, laboriously, as if he had
not arrived at that patent fact yet
even after the hardest mental
labour.

"Cut it off and sold it," said
Della. "Don't you like me just as
well, anyhow? I'm me without my
hair, ain't I?"

Jim looked about the room
curiously.

"You say your hair is gone?" he
said, with an air almost of idiocy.

"You needn't look for it," said
Della. "It's sold, I tell you—sold
and gone, too. It's Christmas Eve,

boy. Be good to me, for it went for you. Maybe the hairs of my head were numbered," she went on with a sudden serious sweetness, "but nobody could ever count my love for you. Shall I put the chops on, Jim?"

Out of his trance Jim seemed quickly to wake. He enfolded his Della. For ten seconds let us regard with discreet scrutiny some inconsequential object in the other direction. Eight dollars a week or a million a year—what is the difference? A mathematician or a wit would give you the wrong answer. The magi brought valuable gifts, but that was not among them. This dark assertion will be illuminated later on.

Jim drew a package from his overcoat pocket and threw it upon the table.

"Don't make any mistake, Dell," he said, "about me. I don't think there's anything in the way of a haircut or a shave or a shampoo that could make me like my girl any less. But if you'll unwrap that package you may see why you had me going a while at first."

White fingers and nimble tore at the string and paper. And then an ecstatic scream of joy; and then, alas! a quick feminine change to hysterical tears and wails, necessitating the immediate employment of all the comforting powers of the lord of the flat.

For there lay The Combs—the set of combs, side and back, that Della had worshipped for long in a Broadway window. Beautiful combs, pure tortoise shell, with jeweled rims—just the shade to wear in the beautiful vanished hair. They were expensive combs, she knew, and her heart had simply craved and yearned over them without the least hope of possession. And now, they were hers, but the tresses that should have adorned the coveted adornments were gone.

But she hugged them to her bosom, and at length she was able to look up with dim eyes and a smile and say: "My hair grows so fast, Jim!"

And then Della leaped up like a little singed cat and cried, "Oh, oh!"

Jim had not yet seen his beautiful present. She held it out to him eagerly upon her open palm. The dull precious metal seemed to flash with a reflection of her bright and ardent spirit.

"Isn't it a dandy, Jim? I hunted all over town to find it. You'll have to look at the time a hundred times a day now. Give me your watch. I want to see how it looks on it."

Instead of obeying, Jim tumbled down on the couch and put his hands under the back of his head and smiled.

"Dell," said he, "let's put our Christmas presents away and keep 'em a while. They're too nice to use just at present. I sold the watch to get the money to buy your combs. And now suppose you put the chops on."

The magi, as you know, were wise men—wonderfully wise men who brought gifts to the Babe in the manger. They invented the art of giving Christmas presents. Being wise, their gifts were no doubt wise ones, possibly bearing the privilege of exchange in case of duplication. And here I have lamely related to you the uneventful chronicle of two foolish children in a flat who most unwisely sacrificed for each other the greatest treasures of their house. But in a last word to the wise of these days let it be said that of all who give gifts these two were the wisest. Of all who give and receive gifts, such as they are wisest. Everywhere they are wisest. They are the magi.

Egg Nog

8 EGGS
3/4 CUP SUPERFINE GRANULATED
 SUGAR
4 CUPS (1 QUART) HALF-AND-HALF
1 TEASPOON GROUND ALLSPICE
1 TEASPOON GROUND CINNAMON
3 TEASPOONS GROUND NUTMEG
2 CUPS (1 PINT) WHIPPING CREAM
YOUR CHOICE OF RUM, BRANDY, OR
 WHISKEY

1. Separate the eggs.
2. Beat yolks with electric mixer until foamy and thickened.
3. Add 1/2 cup sugar, allspice, cinnamon, and 2 teaspoons of the nutmeg and mix well.
4. Add half-and-half and blend well.
5. Beat egg whites until they have soft peaks.
6. In a separate bowl, beat the cream with 1/4 cup sugar until thick.
7. Fold whipped egg whites and cream into the yolks and half-and-half mixture.
8. Sprinkle with remaining ground nutmeg.
9. Chill. Serve from a punchbowl with a ladle.
10. Add rum, brandy, or whiskey to taste in each cup.

The Last Dream of the Old Oak Tree

HANS CHRISTIAN ANDERSEN

In the forest, high up on the steep shore, hard by the open seacoast, stood a very old oak tree. It was exactly three hundred and sixty-five years old, but that long time was not more for the tree than just as many days would be to us men. We wake by day and sleep through the night, and then we have our dreams; it is different with the tree, which keeps awake through three seasons of the year, and does not get its sleep till winter comes. Winter is its time for rest, its night after the long day which is called spring, summer, and autumn.

On many a warm summer day the ephemera, the fly that lives but for a day, had danced around the tree's crown—had lived, enjoyed, and felt happy; and when the tiny creature rested for a moment in quiet bliss on one of the great fresh oak leaves, the tree always said:

"Poor little thing! Your whole life is but a single day! How very short! It's quite melancholy!"

"Melancholy! Why do you say that?" The ephemera would then

always reply. "It is wonderfully bright, warm, and beautiful all around me, and that makes me rejoice!"

"But only one day, and then it's all done!"

"Done!" repeated the ephemera. "What's the meaning of 'done'? Are you 'done,' too?"

"No; I shall perhaps live for thousands of your days, and my day is whole seasons long! It's something so long, that you can't at all manage to reckon it out."

"No? Then I don't understand you. You say you have thousands of my days; but I have thousands of moments, in which I can be merry and happy. Does all the beauty of this world cease when you die?"

"No," replied the tree; "it will certainly last much longer—far longer than I can possibly think."

"Well, then, we have the same time, only that we reckon differently."

And the ephemera danced and floated in the air, and rejoiced in her delicate wings of gauze and velvet, and rejoiced in the balmy breezes laden with the fragrance of meadows and of wildroses and elder-flowers, of the garden hedges, wild thyme, and mint, and daisies; the scent of these was all so strong that the ephemera was almost intoxicated. The day was long and beautiful, full of joy and of sweet feeling, and when the sun sank low the little fly felt very agreeably tired from all its happiness and enjoyment. The delicate wings would not carry it any more, and quietly and slowly it glided down upon the soft grass blade, nodded its head as well as it could

nod, and went quietly to sleep—and was dead.

"Poor little ephemera," said the oak. "That was a terribly short life!"

And on every summer day the same dance was repeated, the same question and answer, and the same sleep. The same thing was repeated through whole generations of ephemera, and all of them felt equally merry and equally happy.

The oak stood there awake through the spring morning, the noon of summer, and the evening of autumn; and its time of rest, its night, was coming on apace. Winter was approaching.

Already the storms were singing their "good-night, good-night!" Here fell a leaf and there fell a leaf.

"We'll rock you, and dandle you! Go to sleep, go to sleep! We sing you to sleep, we shake you to sleep, but it does you good in your old twigs, does it not? They seem to crack for very joy! Sleep sweetly, sleep sweetly! It's your three hundred and sixty-fifth night. Properly speaking, you're only a stripling as yet! Sleep sweetly! The clouds strew down snow, there will be quite a coverlet, warm and protecting, around your feet. Sweet sleep to you, and pleasant dreams!"

And the oak tree stood there, denuded of all its leaves, to sleep through the long winter, and to dream many a dream, always about something that had happened to it—just as in the dreams of men.

The great oak had once been small—indeed, an acorn had been its cradle. According to human computation, it was now in its fourth century.

It was the greatest and best tree in the forest; its crown towered far above all the other trees, and could be descried from afar across the sea, so that it served as a landmark to the sailors; the tree had no idea how many eyes were in the habit of seeking it. High up in its green summit the wood-pigeon built her nest, and the cuckoo sat in its boughs, and sang his song; and in autumn, when the leaves looked like thin plates of copper, the birds of passage came and rested there, before they flew away across the sea; but now it was winter, and the tree stood there leafless, so that every one could see how gnarled and crooked the branches were that shot forth from its trunk. Crows and rooks came and took their seat by turns in the boughs, and spoke of the hard times which were beginning, and of the difficulty of getting a living in winter.

It was just at the holly Christmas time when the tree dreamed its most glorious dream.

The tree had a distinct feeling of the festive time, and fancied he heard the bells ringing from the churches all around; and yet it seemed as if it were a fine summer's day, mild and warm. Fresh and green he spread out his mighty crown; the sunbeams played among the twigs and leaves; the air was full of the fragrance of herbs and blossoms; gay butterflies chased each other to and fro. The ephemeral insects danced as if all the world were created merely for them to dance and be merry in. All that the tree had experienced for years and years, and that had happened around him, seemed to pass by him again, as in a festive pageant. He saw the knights of

ancient days ride by with their noble dames on gallant steeds, with plumes waving in their bonnets and falcons on their wrists. The huntinghorn sounded, and the dogs barked. He saw hostile warriors in colored jerkins and with shining weapons, with spear and halberd, pitching their tents and striking them again. The watchfires flames up anew, and men sang and slept under the branches of the tree. He saw loving couples meeting near his trunk, happily, in the moonshine; and they cut the initials of their names in the gray-green bark of his stem. Once—but long years had rolled by since then—cithern and aeolian harps had been hung up on his boughs by merry wanderers; and now they hung there again, and once again they sounded in tones of marvelous sweetness. The wood-pigeons cooed, as if they were telling what the tree felt in all this, and the cuckoo called out to tell him how many summer days he had yet to live.

Then it appeared to him as if new life were rippling down into the remotest fibre of his root, and mounting up into his highest branches, to the tops of the leaves. The tree felt that he was stretching and spreading himself, and through his root he felt that there was life and motion even in the ground itself. He felt his strength increase, he grew higher, his stem shot up unceasingly; he grew more and more and his crown became fuller, and spread out; and in proportion as the tree grew, he felt his happiness increase, and his joyous hope that he should reach even higher—quite up to the warm brilliant sun.

Already he had grown high above the clouds, which floated past

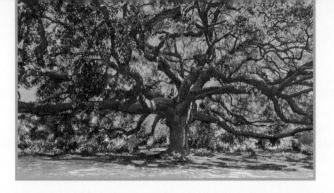

beneath his crown like dark troops of passage birds, or like great white swans. And every leaf of the tree had the gift of sight, as if it had eyes wherewith to see; the stars became visible in broad daylight, great and sparkling; each of them sparkled like a pair of eyes, mild and clear. They recalled to his memory well-known gentle eyes, eyes of children, eyes of lovers who had met beneath his boughs.

It was a marvelous spectacle, and one full of happiness and joy! And yet amid all this happiness the tree felt a longing, a yearning desire that all the other trees of the wood beneath him, and all the bushes, and herbs, and flowers, might be able to rise with him, that they too might see this splendor, and experience this joy. The great majestic oak was not quite happy in his happiness, while they all, great and little, were not about him, and this feeling of yearning trembled through his every twig, through his every leaf, warmly and fervently as through a human heart.

The tree waved his crown to and fro, as if he sought something in his silent longing, and he looked down. Then he felt the fragrance of thyme, and soon afterward the more powerful scent of honeysuckle and violets; and he fancied he heard the cuckoo answering him.

Yes, through the clouds the green summits of the forest came peering up, and under himself the oak saw the other trees, as they grew and raised themselves aloft. Bushes and herbs shot up high, and some tore themselves up bodily by the roots to rise the quicker. The birch was the quickest of all. Like a white streak of lightning, its slender stem shot upwards in a zigzag line, and the branches spread around it like green gauze and like banners; all the woodland natives, even to the brown-plumed rushes, grew up with the rest, and the birds came too, and sang; and on the grass blade that fluttered aloft like a long silken ribbon into the air, sat the grasshopper cleaning his wings with his leg; the May beetles hummed, and the bees murmured, and every bird sang in his appointed manner; all was song and sound of gladness up into the high heaven.

"But the little blue flower by the waterside, where is that?" said the oak, "and the purple bellflower and the daisy?"—for, you see, the old oak tree wanted to have them all about him.

"We are here—we are here!" was shouted and sung in reply.

"But the beautiful thyme of last summer—and in the last year there was certainly a place here covered with lilies of the valley—and the wild apple tree that blossomed so splendidly! And all the glory of the wood

that came year by year—if that had only just been born, it might have been here now!"

"We are here, we are here!" replied voices still higher in the air. It seemed as if they had flown on before.

"Why, that is beautiful, indescribably beautiful!" exclaimed the old oak tree rejoicingly. "I have them all around me, great and small; not one has been forgotten! How can so much happiness be imagined? How can it be possible?"

"In heaven, in the better land, it can be imagined, and it is possible!" the reply sounded through the air.

And the old tree, who grew on and on, felt how his roots were tearing themselves free from the ground.

"That's right, that's better than all," said the tree. "Now no fetters hold me! I can fly up now, to the very highest, in glory and in light! And all my beloved ones are with me, great and small—all of them, all!"

That was the dream of the old oak tree; and while he dreamt thus, a mighty storm came rushing over land and sea—at the holy Christmastide. The sea rolled great billows toward the shore; there was a cracking and crashing in the tree—his root was torn out of the ground in the very moment while he was dreaming that his root freed itself from the earth. He fell. His three hundred and sixty-five years were now as the single day of the ephemera.

On the morning of the Christmas festival, when the sun rose, the storm had subsided. From all the churches sounded the festive bells, and

from every hearth, even from the smallest hut, arose the smoke in blue clouds, like the smoke from the altars of the druids of old at the feast of thanks-offerings. The sea became gradually calm, and on board a great ship in the offing, that had fought successfully with the tempest, all the flags were displayed, as a token of joy suitable to the festive day.

"The tree is down—the old oak tree, our landmark on the coast!" said the sailors. "It fell in the storm of last night. Who can replace it? No one can."

This was the funeral oration, short but well-meant, that was given to the tree, which lay stretched on the snowy covering on the seashore, and over its prostrate form sounded the notes of a song from the ship, a carol of the joys of Christmas, and of the redemption of the soul of man by His blood, and of eternal life.

Sing, sing aloud, this blessed morn—
It is fulfilled—and He is born:
Oh, joy without compare!
Hallelujah, Hallelujah!

THUS SOUNDED THE OLD PSALM-TUNE, and every one on board the ship felt lifted up in his own way, through the song and the prayer, just as the old tree had felt lifted up in its last, its most beauteous dream in the Christmas night.

Crispy Gingerbread Cookies

7 CUPS WHITE FLOUR

3 TEASPOONS BAKING SODA

3 TEASPOONS GROUND CINNAMON

3 TEASPOONS GROUND CLOVES

3 TEASPOONS GROUND GINGER

2 CUPS WHITE SUGAR

$^1\!/_2$ CUP BUTTER, AT ROOM
 TEMPERATURE

$^1\!/_2$ CUP BACON FAT, AT ROOM
 TEMPERATURE, OR ANOTHER $^1\!/_2$
 CUP BUTTER

1 CUP DARK (OR LIGHT) CORN SYRUP

1 $^1\!/_4$ CUPS HEAVY CREAM

1. In a bowl, mix together the flour, baking soda, and spices.
2. Cream together the sugar, butter, and bacon fat in a separate bowl. Stir in the corn syrup and heavy cream. Slowly add the dry ingredients and blend well.
3. Flour your hands and toss the dough quickly on a floured surface. Roll into a ball, then divide into 3 balls. Cover each with waxed paper and put them into the refrigerator to chill for at least 2 hours.
4. Preheat the oven to 375°F and line baking sheets with parchment paper.
5. Turn the dough out onto a lightly floured surface, one ball at a time, and roll each one out. The cookies can be made pretty thin, or you can do them thicker, if you prefer. The dough

94

can also be rolled directly onto waxed paper.

6. Cut with cookie cutters. Use a spatula to move the shapes onto cookie sheets. If you are going to decorate without icing, do so before baking cookies.

7. Bake approximately 12 minutes. (If you have made your cookies thicker, lower the oven temperature to 350°F and bake slightly longer, for 15 to 20 minutes.) When cookies begin to brown, remove them from the oven and slide the parchment off the baking sheet. When the cookies have cooled a bit, slide them off the parchment. Cool the cookie sheet before using it again.

Designed by Gregory Wakabayashi

A Little Book of Christmas Stories and Recipes
compilation copyright © 2001 by Welcome Enterprises, Inc.

For information, write Andrews McMeel Publishing,
an Andrews McMeel Universal company,
4520 Main Street, Kansas City, Missouri 64111.

ISBN: 0-7407-1942-4

Library of Congress Catalog Card Number
2001086429